Digital Photographic Imaging Glossary

DIGITALPHIL.CA

Phil Taylor

© 2002 by Phil Taylor. All rights reserved.

No part of this publication may be reproduced, stored in a retrieval system, or transmitted, in any form or by any means, electronic, mechanical, photocopying, recording, or otherwise, without the written prior permission of the author.

National Library of Canada Cataloguing in Publication Data

Taylor, Phil, 1967-
 Digital photographic imaging glossary

ISBN 1-55369-253-5

 1. Photography—Digital techniques—Dictionaries. 2. Image processing—Digital techniques—Dictionaries. I. Title.

TR267.T39 2002 778.3 C2002-900884-0

TRAFFORD

This book was published *on-demand* in cooperation with Trafford Publishing. On-demand publishing is a unique process and service of making a book available for retail sale to the public taking advantage of on-demand manufacturing and Internet marketing.**On-demand publishing** includes promotions, retail sales, manufacturing, order fulfilment, accounting and collecting royalties on behalf of the author.

Suite 6E, 2333 Government St., Victoria, B.C. V8T 4P4, CANADA
Phone 250-383-6864 Toll-free 1-888-232-4444 (Canada & US)
Fax 250-383-6804 E-mail sales@trafford.com
Website www.trafford.com
TRAFFORD PUBLISHING IS A DIVISION OF TRAFFORD HOLDINGS LTD.
Trafford Catalogue #02-0066 www.trafford.com/robots/02-0066.html

10 9 8 7 6 5 4 3 2 1

Digital Photographic Imaging

INTRODUCTION

Digital photography can be a simple undertaking or very complex if you allow it to be. My choice was to refer to as many sources of information as were available. Along with courses, tutorials and other forums, this glossary is an ideal companion as you venture into this new field of photography and digital imaging.

I have researched numerous resources and have finally come to this point. While I was once looking for this information I was welcomed with a rapid accumulation of terminology. The vocabulary associated with digital photographic imaging is used in a variety of fields to express similar concepts. To prevent misunderstandings it is essential to clarify concepts and establish definitions – definitions that are thorough, uncomplicated and easily understood.

This book does not replace your user manual for your software or hardware. This glossary generally does not excessively contain commercial software or hardware related terminology. This is appropriate as it simplifies things into two distinct categories: your manuals and this glossary.

Some authors profess that you don't have to read their work from front to back; that you should in fact, just consider it for occasional reference. Well, I disagree. I highly suggest that it be read like a novel, cover to cover. Linear enjoyment! This is the first edition and inevitably there will be inaccuracies. Technology changes and so will the book! I welcome any corrections, suggestions or rave reviews. Send them to me at: http://www.digitalphil.ca

Digital Photographic Imaging

Thank-you...

I owe some credit to my partner in life Rosanne and my daughter Brooke. I would also like to extend my thanks to the following people:

Tony Bounsall	James Ferns	David Pollock
Joti Bryant	Nina Forsyth	Greg Ridout BSc
Roderick Burkhart	Dave MacPherson	Brian Stennes
Norman Charbonneau	Jono Moore	Pierre Vaudry
George Clement	Larry Moss	Andrew Willard
Simon Desrochers	Colin Neave	
Richard Fenner	Ron O'Connell	

Legal Stuff...

The term graphic will refer to all manners of illustration. All text and graphics appearing in The Digital Photographic Imaging Glossary are the exclusive intellectual property of Phil Taylor and are protected under Canadian and international copyright laws. This document is the sole work and property of the author. This work is for one's own personal use on a strictly informational and non-profit basis.

Permission is not granted for the copying of this intellectual property. This work may not be transmitted, transferred to a computer, published, redistributed or sold for profit, reproduced, stored in a retrieval system, manipulated, projected, or altered in any way, including without limitation any digitization or synthesizing of the images, alone or with any other material, by use of computer or other electronic means or any other method or means now or hereafter known, without the written consent of Phil Taylor, and payment or arrangement thereof.

No graphics are within Public Domain. Use of any graphic as the basis for another graphic concept or illustration is a violation of copyright.

Phil Taylor, author of the Digital Photographic Imaging Glossary, vigorously protects copyright interests. In the event that an infringement is discovered you will be notified and invoiced the industry-standard triple fee for unauthorized usage and/or prosecuted for Copyright Infringement in court, where you will be subject to a fine of $300 000 statutory damages as well as all court costs and attorneys' fees. By purchasing this book you are agreeing to be bound by the terms of this agreement. Purchase is expressly on these conditions, which embodies all of the understandings and obligations between the parties hereto. The author is not held responsible or liable for its content.

Digital Photographic Imaging

The below mentioned names should be considered registered Trade Marks:

3M Corporation™	Acrobat Reader™
Adobe Acrobat™	Adobe Photo Deluxe™
Adobe Systems Inc.™	Advanced Photographic System™
Aldus™	ANSI™
Apple Computer Inc.™	ASA™
Canon™	Centronics™
Click!™	CompactFlash™
CompuServe™	Epson™
Firewire™	Fuji™
Hewlett Packard™	High Definition Television™
I-Link™	ISO™
Jaz™ disks	Kodak™
Linux™	Live Picture™
Lynx™	Mac OS™
Microsoft Windows™	Microsoft™
Microsoft™	Minolta™
Nikon™	PC Card™
Phillips™	Smart Media™
Sony™	Texas Instruments™
Wilhelm Imaging, Inc.™	Matrix® (©Warner Bros.)

Notes…

📽 - This film canister will indicate a term originally relevant to film based photography.

Glossary- Throughout this book, all words with underlining indicate that the word is "linked" to a definition of that word. This will allow a transition from a printed book to an electronic version of the glossary. It is now necessary for a website introduction. These days it seems mandatory to have a website companion for any projects undertaken. The website mentioned above is exactly just that for the glossary. Visit the site to find out where things are headed.

…and remember what Malcom Forbes said, "The person with the most toys when he dies wins!"

© Copyright 2000 by Phil Taylor. All rights reserved.
Contact the author by e-mail: digitalphil2000@hotmail.com

Digital Photographic Imaging

#

01-Bit Colour: The lowest number of colours per <u>pixel</u> in which a graphics file can be stored. In 1-bit colour, each pixel is either black or white and each pixel has 1 bit assigned to it.

08-Bit Colour: A system that allocates 8 bits to represent each pixel, representing 256 possible colours. In 8-bit colour, each pixel has eight bits assigned to it. This is used with some images on the web and newsletters. The file format <u>gif</u> uses this <u>bit-depth</u>.

08-Bit Greyscale: A system that allocates 8 bits to represent each pixel, representing 256 possible shades of grey. In 8-bit greyscale, each pixel has eight bits assigned to it.

16-Bit Colour: A system that uses 16 bits to represent each pixel. In 16-bit colour, each pixel has 16 bits assigned to it, representing 65 thousand (65,536) possible colours. 16-bit colour is often referred to as <u>high colour</u>, or "Thousands of Colours".

24-Bit Colour: This is known as "<u>true colour</u>"; referring to a system that uses 24 bits of colour data to represent each pixel. In 24-bit colour, each pixel has 24 bits assigned to it, representing 16.7 million (16 777 216) possible colours allowing for subtle gradations of colour. 8 bits (one byte) are assigned to each of the red, green, and blue components of a pixel

32-Bit Colour: A system that uses 32 bits of colour data to represent each pixel. 32-bit colour embodies 24-bit pixels with an additional 8-bit <u>alpha channel</u>.

36-Bit Colour: A system that uses 36 bits of colour data to represent each pixel.

Digital Photographic Imaging

3D or 3-D: The label of 3D is usually reserved for computer-generated objects, formulae, and various other effects. See ray tracing.

A

A/D Converter: Analog-to-Digital Converter. Any device that converts analog information (a photograph or video) into digital information that a computer can store and manipulate.

Aberration: A lens or scanning device's failure to produce a geometrical or chromatic correlation between a subject and its image.

Access Time: The time required for a data storage device to locate and retrieve data. This is measured in milliseconds. Also referred to as seek time.

Achromatic: Any object that is free from colour is considered achromatic.

Acid Migration: An example could be a photograph with old matting. The matting may have a high acidity level (low pH rating) that could migrate into the print, thus damaging it. Your print could suffer from discolouration at the edges or over its entire surface, effectively destroying the quality of the print.

Acquisition: Part of the process where by a graphic is captured for insertion into an image-editing program. This form of importing is accomplished by going through the TWAIN module, (also know as a plug-in) which allows you to interface with a scanning device, and then finally acquire an image.

Acrobat: A software program from Adobe Systems Inc. that allows documents to retain the typography, layout,

Digital Photographic Imaging

graphics, and colour of the original document in Acrobat's native PDF format. This allows for the viewing and distribution of various file formats by Adobes "Acrobat Reader", eliminating the need for anyone to have the original application in which the file was created.

Active Pixel Sensor: CMOS APS technology is a natural development / outgrowth of CMOS-based cameras. The APS variant to CMOS offers reduced fixed-pattern noise as well as reduced dark-current which enhances signal-to-noise ratio.

Active-Matrix Display: Otherwise known as a Thin-Film Transistor (TFT) display, and more widely known as a Liquid Crystal Display. LCD technology is commonly used in digital cameras, and monitors for desktop and laptop computers providing crisp, vivid images.

Acutance: The rendering of a subject's sharp edge as a distinctly sharp edge in a print. Essentially, the higher the resolution, the higher the acuity attained.

Adaptive Palette: A palette of colours consisting only of those sampled directly from an image in the process of compressing the image file size.

Additive Colour: Red, Green, and Blue are known as additive colours. If they are added together at 100% intensity, they make white. When the additive primaries are mixed in equal amounts, a neutral (grey) tone is produced. When combined at various (unequal) intensities a wide-ranging palette (gamut) of colours may be produced. When two additive primaries are mixed at 100% intensity, one of the subtractive primaries is produced and is referred to as the complimentary colour (red + blue = magenta; red + green = yellow; green + blue = cyan). This holds true for the subtractive colours as well.

Digital Photographic Imaging

Adjacency Effect: Adjacent or surrounding colours may affect the perception of a particular colour.

Advanced Photographic System 📷: A non-sprocket film format measuring 30.2mm x 16.7mm, developed jointly by Kodak, Canon, Fuji, Minolta, and Nikon and launched in April 1996. Three print formats are available, C- Classic (3 to 2), H- HDTV (16 to 9) and P- Panoramic (3 to 1). Utilising a transparent magnetic film backing it can record such information as exposure, date, and flash data to be interpreted by photofinishers. See also APS.

Algorithm: A set of instructions to solve a specific problem or accomplish a particular task. Imaging software programs consist of algorithms written in computer language.

Aliasing: The jagged stair-casing effect of curves and angular lines in a raster graphic. This is due to the fact that these images are comprised of square pixels at a fixed size or resolution. Vector graphics though, are not.

Alley: The margin or white space separating the columns on a page layout. Sometimes referred to as "Gutter".

Alpha Channel: An 8-bit greyscale component of an image that may be used for effects or for representing masking information.

Ambient: Light that is naturally occurring.

Anaglyphs: A stereoscopic still picture in which the right component of a composite image (red) is superimposed on the left component in a contrasting colour (green) to produce a three-dimensional effect when viewed through respectively coloured lenses.

Digital Photographic Imaging

Analog / Analogue: A representation of directly measurable quantities as being infinitely variable, as may be illustrated by paper records, notes, microfilm or video tapes. See also Digital.

Angle of View: Angle of the subject as observed by the focal plane.

ANSI: American National Standards Institute. The Institute's undertaking is to enhance both the competitiveness of business and quality of life, by supporting and smoothing the progress of voluntary standards. This glossary has utilised ANSI as a reference during its creation.

Anti-Aliased: A fixed softening at the edge of a selection. This helps reduce the stair-stepping effect where individual pixels are visible through averaging of pixel values. See also Aliasing.

Aperture: A lens' opening. This determines how much light is allowed to pass through to the film of a 35mm camera or onto the array of a digital camera while the shutter is open. The aperture can be fixed or adjustable and is scaled in f-stops. The larger the f-stop, the smaller the lens opening.

Aperture Priority: The aperture remains at the last setting, while the camera automatically sets the correct shutter speed.

Application: This refers to a particular program that you may be using, or the software that will run a unique file that you have.

APS: A new standard in film oriented photography developed by Kodak and four other companies - Canon, Fuji, Minolta and Nikon. The system is based on an

innovative film format, camera, and photofinishing process. See also Advanced Photographic System.

Archival Medium: A substrate that can retain information indefinitely without significant loss, if stored under the right conditions. Materials must pass the ANSI Photographic Activity Test (PAT), which produces a noteworthy figure that is useful for comparison purposes.

Archive: A long-lasting method of storing data that provides security and controlled access to the data. Generally data will be archived on some form of magnetic or optical media such as disk, a tape, or optical media (disc). This term can also be applied to the longevity of the substrate (archival) in the case of prints; the ink printed on them (pigmented inks vs. dye-based inks); and their ability to retain colour and contrast. Avoidance of acidic paper, cardboard and polyvinyl chloride (PVC) is paramount. More suitable materials are readily available. With regards to environmental conditions, relative humidity is a very important factor and should be maintained at around 30-40%. Storage temperature is recommended to be around 5 degrees Celsius or below. Atmospheric contaminants, such as Ozone and Sulphur are best avoided. See also Fading.

Area-array: A CCD where the elements are arranged in a matrix, rather than a linear array.

Array: A CCD where a number of elements are arranged in a row or a column. A one-dimensional array is referred to as a vector; a matrix is two-dimensional.

Art / Artwork: All of the illustrative, photographic, and pictorial content in a page layout, excluding the text.

Artefact / Artifact: An unwanted element of noise, blooming, aliasing or colour fringing in an electronic image; dirt or marks on a piece of film, or an abnormal

Digital Photographic Imaging

pixel in a digital image. Can occur during the electronic capture, manipulation, or output of an image.

ASA or ISO: The American Standards Association. The assigned film "speed"! It does not change, but it can be "pushed" which is in reference to E.I. or Exposure Index. See also ISO.

ASCII: American Standardised Code for Information Interchange. The standard code for representing printable alphanumeric and non-printing control characters as binary data. ASCII files are used to store image and text data, for transmission between computers and information systems.

Aspect Ratio: The relationship between the horizontal and vertical dimensions of an image. For example, 35 mm film is 36 mm x 24 mm, or a ratio of 3 to 2.

Astigmatism: The inability of a lens to focus horizontal and vertical lines near the edge of the focal point, resulting in a blurred and imperfect image.

Author's Alterations: Author's corrections, are changes made to layout after proofing due to the client's errors or changes. These changes are billable to the client.

Auto Focus: A feature that will automatically focus on whatever is in the centre of the lens' viewing area. Auto focus actually moves the lenses within the lens unit in order to achieve focus, unlike some cameras that are "fixed focus" where the lens is in a fixed position.

Auto Print: A printer function on some printers that allows images to be printed from a memory card such as CompactFlash, Smart Media; and PC Card.

B

Background Processing: A computer attribute that allows an operator to continue working while the computer executes another action, such as spooling to a printer. This type of processing is also known as multitasking or multithreading. See also <u>Buffer</u>.

Backing Up: Printing on the opposite side of a sheet that has already been printed. Also to make copies of data to insure against loss.

Banding: An <u>artefact</u> inherent in digital imaging where a <u>contouring</u> or <u>posterization</u> of tones or colours appears in a gradient or blend. The graduated colours break into larger blocks of a single colour, reducing the "smooth" look. <u>Postscript</u> I and II encountered this problem till the implementation of Postscript III. Banding is also observed as a printing defect seen in the direction of the printing head, caused by a jet or printhead that is not operating properly. Usually this indicates that the heads need cleaning, or that the ink supply is low.

Bandwidth: The amount of data that can travel simultaneously between multiple points (elaborate network) in a specific time. Normally represented as bits or bits per second (bps).

Banner: A title or headline that extends across the width of a full page or double page spread. A style of advertising or display graphic on a web page.

Baseline: The imaginary line on which non-descending letters of text sit.

Batteries: As the primary power source for portable devices, this is a topic you will want to be informed on. One should be wary of the unique (proprietary) batteries

Digital Photographic Imaging

that power some devices, as this can spell trouble if your batteries are exhausted and standard retail batteries are the only things "available". Look at purchasing a camera that accepts readily available batteries like AA or AAA. As far as battery formulations go, the chemistry for the button type batteries lean favourably towards Lithium Ion. Silver oxide is the next best offering. For generic rechargeables, Nickel Metal Hydride is at the forefront. Be aware of the rated Voltage of you rechargeable batteries, as some digital cameras won't even work if this rating is too low, even when the battery is fully charged! Just so you know, a higher mAh rating equals better service.

Baud Rate: The transmission speed at which your modem can transmit and receive data travelling via the Internet or other systems. It was the prevalent measure for data transmission speed until replaced by a more accurate term, bps (bits per second).

Bayer Pattern: A pattern of four pixels in an imaging array (TV's and monitors) that are colour-filtered blue, red, green, and another green. The two greens are used to match the human visual system, as human sight has a green bias.

Beta Version: A version of software that is pre-released to selected users for faultfinding prior to the final release.

Bezier Curves: These are curves that are interpolated between vector nodes. These graphic components are described mathematically as vector objects by software illustration programs. In comparison with raster images, vector or object oriented graphics are resolution independent and may be output at any size. The final resolution is only dependent upon the resolution of the output device.

Digital Photographic Imaging

Bicubic: A form of <u>interpolation</u> that obtains a new pixel value by averaging adjacent pixel values. This method is the most accurate (in that it is more true to the original) and may also be more time intensive.

Bilinear: Another form of <u>interpolation</u> that obtains a new pixel value by averaging values of four adjacent pixels.

Binary: A numbering system using two numbers, 0 & 1; two states, off & on; or as in imaging, the two colours black & white (1-bit).

Binning: The amalgamation of several pixels in a CCD to give the equivalence of a single larger pixel, thus boosting low signals.

Bit Depth: The number of bits per pixel used to represent the colour value or tonal levels of each individual pixel. <u>1-bit</u> displays two colours, and <u>24-bit</u> displays 16.7 million colours. The higher the bit depth the more colours or shades of grey, the greater the colour fidelity and the closer to photo-real.

Bit: The binary digit. The smallest unit of digital data. A single bit can exist in two possible states, off & on. A single bit can represent two possible values, such as 0 or 1. A <u>byte</u> is 8 bits.

Bitmap: In a bitmap the bits that describe an image are mapped to specific locations in a grid, otherwise known as a <u>raster</u> graphic. Each bit is located by X & Y co-ordinates, and assigned a value – greyscale or colour. Images with a bit depth of one bit per pixel may represent one of two possible tonal levels, black or white; bitmaps are sometimes referred to as a 1-bit image. Bitmap images have a fixed resolution.

Bitmapped: An image that has been converted to a bitmap.

Digital Photographic Imaging

Bits per second: See Baud Rate.

Black Noise: Aberrant pixels or "noise" a scanner introduces when scanning. If you scanned a black sample in RGB mode with a scanner of questionable quality, you would get grey instead of jet black. All of this is measured as a signal to noise ratio measured in decibels, dB.

Black Point: A pixel with a numerical value 0, having no reflectance or transmittance. When viewing an image's Histogram, the area representing the darkest area of the image is the Black Point.

Black: The absence of light. The colour of an object that reflects no wavelengths of light. An ink, toner, dye, pigment or other colourant that absorbs all wavelengths of light. The product of all additive colours (CMYK).

Bleed: A design in which a graphic extends to the edge of the page with no margin. Area is created that extends beyond the trim marks of the page so that when the page is trimmed inked areas extend to the edges of the page. This is also referred to as a printing property caused by ink spreading or diffusing on or into the substrate printed upon.

Blend: A gradient of colours or graduated fill.

Blooming: A phenomenon experienced by older CCD's. Caused when the electrical charge created exceeds a pixels storage capacity and overflows into neighbouring pixels.

Blow Up: An enlarged reproduction of a photograph or other image element.

BMP: An uncompressed file format often used by computers to save rasterised graphics; mapping the image pixel by pixel, colour by colour. Most often used as a Windows wallpaper format. See also Bitmap.

Digital Photographic Imaging

Bond: A grade of paper for writing or printing. Usually designed for quality and permanence.

Brightness Range: A value that measures the range from absolute black to absolute white and assigns a magnitude. Otherwise known as <u>Dynamic Range</u>.

Brightness: The measure of the perceptible amount of light emitted or reflected by an object or surface. The characteristic brightness of paper is defined by the percentage of "reflectance" of a 457-nanometer radiation source. The value of a pixel in an electronic image, representing its lightness value from black to white. Brightness levels range in value from 0 (black) to 255 (white).

Buffer: A space in hardware or software that holds temporary information. Printers "spool" data to a buffer. CD-ROM drives buffer information when burning recordable CD's.

Bug: Due to the abundance and combinations of operating systems and applications that run on those systems, problems are bound to occur. These errors, crashes or other glitches are referred to as "Bugs". <u>Beta</u> testing is a form of faultfinding that is used prior to the release of the marketable version of some software.

Burn: A darkroom technique where light energy is used to darken or add exposure to an area of photographic paper. Some photography software programs emulate this effect. Known also as the act of recording (burning) a compact disc.

Bus: A common pathway between multiple devices.

© 1999 Phil Taylor

Digital Photographic Imaging

Byte: Binary measurement of 8 bits. The standard unit of measure, with any value between 0 and 255. Equivalent to one text character.

C

Cache: High-speed memory chips that store frequently used instructions or data.

Calibration Bars: Reference tones, colours, or resolution detail added to film, proofs, and other media to monitor the accuracy of system calibration in terms of colour, tonality, registration, and resolution.

Calibration: In computer imaging, the systematic adjustment of standardised tonal and colour reproduction characteristics of one device relative to another. Scanners, monitors, printers and other imaging components are examples of systems requiring calibration.

Camera Testing: When comparing the performance of several cameras, use of a standardised target, light source and fixed distance to create a baseline for comparison. Shooting index cards for lens type, aperture, plus other technical settings would be your primary aim.

Camera-Ready: In "traditional" graphic arts, a hard copy layout that is finished and ready to be photographed in the printer's pre-press shop.

Canvas Size: This is the actual work area containing sampled information from a scanned image. Altering the dimensions will change the size of the work surface by producing a blank border around the image or by cropping off any excess.

Caption: A short descriptive text identifying or referring to a graphic; usually in close proximity to the relevant image.

Digital Photographic Imaging

Cast Coated Paper: A paper on the lower end of the superiority scale, where ink is absorbed quickly because of its paper base. This water fastness leads to rippling when high quantities of ink are applied or if the paper comes in contact with water. Brilliance is low owing to the ink being absorbed by the paper base. All in all this isn't a very durable paper and lacks the real photo feel.

Catchlights: These are little spots of light reflected in the eyes of a person being photographed. These specular highlights are well known to "add life" to a persons eyes.

CCD: Charged Coupled Device. An array of light-sensitive pixels, which produce an electrical charge directly proportional to the light exposed to them. The first main type of CCD is the linear array used in flatbed scanners and studio digital cameras. The other type of CCD is an area-array used in camcorders, many digital cameras, and high-performance scanners.

CD-R: A recordable compact disc. Once material has been written to disc it cannot be erased. If the recording session is closed and the disc is left open, data can be added until the disc is full.

CD-ROM: Compact Disc - Read Only Memory, created and developed by Phillips and Sony. It now generally refers to the unit that reads a CD, but is in fact the actual disc itself. These discs are read only and cannot be erased or written to.

CD-RW: A re-writable compact disc. Data can be added to the disc until the disc is full or the disc can be completely formatted and used again.

Centre Marks: Lines or crosshairs printed at the centre of all sides of a camera-ready layout to assist in positioning

Digital Photographic Imaging

the print area relative to a printing plate. Also called registration marks.

CF Card: Compact Flash Card.

Channel: A single piece of information stored in an image file. A 32-bit colour graphic has three channels, red, green and blue. CMYK graphics require four channels. This embodies 24-bits, with an additional 8-bit alpha channel.

Chipset: A group of chips designed to work as a unit to perform a function.

Chromatic Aberration: An abnormality in camera lenses which takes two forms. *Longitudinal-* different colours of light are focused at different planes.
Lateral- when different coloured light rays hit a lens at an angle. Achromatic lenses correct for two colours and Apochromatic corrects for three.

Chromaticity Diagram: A two-dimensional diagram plotting the co-ordinates of the hue and saturation of a colour.

Chrominance: Chroma is comprised of hue and saturation values, but not luminance. The degree of saturation or purity of a colour. The colour of a pixel.

CIE: Commission Internationale de l'Eclairage. A group introduced in 1931 to establish the now standardised colour space model. See also Colour Model.

Circles of Confusion: Light rays passing through a lens converge towards the focal point in the form of a cone. When focused on the focal point it does so as a circle so small it appears to be a point. If focused beyond the focal point the cone is then severed, creating a larger circle. If

focused before the focal point, the cone is then dispersed creating a blurred image.

CIS: Contact Image Sensor. A type of scanning sensor used in flatbed scanners that is smaller than a CCD. Although it allows for more compact scanners to be built, colour and image quality may not be as good as CCD technology.

Clipping: When darker greyscale values are converted to black and some shadow detail is lost. This may also occur with highlights.

Clock Speed: The speed of a computers bus, but commonly referred to as the computer's CPU speed. Internal timing pulses generated by a quartz crystal determine this and are measured in MHz or GHz. A 200MHz CPU receives 200 million cycles per second.

Cloning: Copying groups of pixels from one part of a digital image to another.

Close-up Lens: A close-up lens +1 will let you focus one meter away. A +3 will let you focus 1/3 of a meter away, no matter what the focal length. There may also be a softening of the image, especially at the edges. Extension tubes or bellows are the best choice for close-ups, but reduce available light. To capture life size close-ups (1 to 1 on neg.) the film-to-subject distance is 4X a lens' focal length. The lens extension must be 2X the focal length.

CLUT: See Colour Look-up Table

CMOS: Complementary Metal Oxide Semiconductor. A type of imaging device widely used as a light sensor for digital and video cameras. CMOS imaging sensors require less power to operate than a CCD, but they require more

Digital Photographic Imaging

light to capture an image. Resolution and contrast are of a lower standard than the traditional CCD.

CMYK & CMY: An acronym standing for Cyan, Magenta, Yellow and Black. One of several colour encoding systems used by printers for combining primary colours to produce a full-colour image. The subtractive colour system or secondary colours for printed media. Although CM&Y are the main components to the system, black is introduced to output true black. This is due to the physical limitations of inks. Secondary colours are created when primary colours are paired. If two additive primaries are mixed at 100% intensity, one of the subtractive primaries is produced; red + blue = magenta; red + green = yellow; green + blue = cyan. See also Colour Systems.

Cockle: The tendency for paper to buckle permanently when too much liquid is applied. This frequently occurs when a large volume of water-based ink is applied to a substrate.

Collate: To gather sheets together in preparation for binding.

Collect: See Acquisition.

Colour Balance: The relative mix of colour primaries necessary to produce a neutral grey. Also referred to as "grey balance" or "white balance" in video.

Colour Bars: Colour samples used to measure and monitor colour reproduction quality. Usually printed along the border of a graphic. Also known as a colour control bar or strip.

Colour Blindness: It is surprising how little is being done in the way of digital imaging projects that consider this visual restriction. Projects (perhaps webpage design) that

Digital Photographic Imaging

have a strong, bright contrast between foreground and background colours are a consideration to ease readability. In web design, using colours alone to indicate navigation is a poor decision. Consider using textures, shading or design in black and white. Try adding colour only for emphasis, only when your design is complete. Colour need not be the only visual cue.

Colour Cast: A greyscale image that has a dominant hue when in fact it should have no chrominance. Colour cast can be directly affected by the light source you are viewing the image with. This cast also exists in a hue that is shifted by the presence of another unwelcome hue. See also Adjacency Effect.

Colour Control Bar: When the control bar is photographed or scanned with the original subject, these known values can be extrapolated through to a digital file. The control bar in the file can then be analyzed to determine whether any corrections are required to be made to the subject within the same file.

Colour Conversion: Usually used in reference to the conversion of RGB mode images to CMYK mode file in preparation for output to hard copy.

Colour Correction: The process of correcting or enhancing the colour of an image. This would include the process of calibration between your computer screen and printer.

Colour Depth: The number of bits with which a display, printer, or camera can represent colours. See bit depth.

Colour Key: A proofing method composed of four acetate sheets, one for each of the four process colours. When the sheets are sandwiched together, the four-colour image is represented. Developed by the 3M Corporation.

Digital Photographic Imaging

Colour Look-up Table (CLUT): A table to translate data intensity values into displayed colours. The CLUT contains 256 entries, and in each entry there is a set of three numbers that correspond to red, green and blue (RGB) respectively, which together make up each new colour.

Colour Management: See Colour Matching System.

Colour Matching: A software/hardware solution designed to ensure systematic calibration and matching of colours between input/output devices in an imaging system or process. A system for controlling the reproduction of colours between display devices and any form of output media. Also known as Colour Management.

Colour Model: A system designed for the numerical specification of the attributes of colour. Some of the colour models used are RGB, HSL, CIE Lab, and CMYK.

Colour Registration: The alignment of the CCD array's red, green, and blue planes. Proper alignment is necessary to produce clean edges between colours. Upon close inspection, a rainbow-like halo next to the fine lines is visible on scanners that have poor registration.

Colour Separation: The transformation of graphics into their colour components (CMYK) so that each part may be output separately to paper, negative film, slides or disposable printing plates. In all cases, the colours are displayed in black or white.

Colour Space: A three-dimensional model like CIE, which represents the three factors of colour; hue, saturation and brightness. A colour wheel for Hue and Saturation may symbolize the colour space, and then typically there will be a coloured slider, which corresponds to the brightness of the selection in the colour wheel.

© 1999 Phil Taylor

Digital Photographic Imaging

Colour Systems: There are two physical colour systems. Firstly, the additive colour system, where the addition of all three <u>primary colours</u> create white. On-screen colours are not the same as the colours reproduced on the page. Secondly, the <u>subtractive colour</u> system works through the subtraction of the <u>secondary colours</u> (on a white surface) to create white. Conditions such as purity of the inks, variation of the ink tints, whiteness of the paper and lighting conditions are all contributing factors to the final appearance of the printed work – not to mention the capacity of each viewers eyes to perceive colour.

Colour Temperature: The measure of the colour of light radiated by an object as it is heated, expressed in terms of degrees Kelvin. Light of lower colour temperature is reddish, as in typical house lighting (3200 K); light of higher colour temperature becomes progressively bluer, as with sunlight (5500 K). This is in respect to light that is radiated from a source or reflected by a material.

Colour Theory: The theoretical ideas and models for measuring, quantifying, specifying, and communicating the characteristics of colour reproduction and colour perception.

Colour Transparency: A positive photographic material composed of emulsion and colour dye layers on a transparent base. Considered a high quality first generation photographic original for digital scanning.

Colour: The characteristics of radiated light, or reflected by an area of an image. Described by a minimum of three components – hue, saturation, and brightness.

Colourimeter: An optical device for measuring colour in a manner similar to that of the human eye by the dissection of incoming light into primary hues of red, green, and blue.

© 1999 Phil Taylor

Digital Photographic Imaging

Often used in the process of matching digital colour values to physical samples.

ColourSync: A colour management system introduced by Apple Computer Inc. to ensure colours throughout its system are accurate and/or uniform.

Coma: Similar to Spherical Aberration. A lens' inability to produce a sharp point image of a subject point that is away from a lens' axis. Light enters a lens from the side and rays from different parts of the lens intersect the axis of those rays at different distances.

CompactFlash: A small solid-state memory card onto which images or other file types can be stored.

Compatibility: The ability of software or hardware to work with another application or platform. Twain driver specifications ensure compatibility.

Complementary Colours: When two equal amounts of primary colours are combined, a complimentary colour is produced. See also Additive Colours or CMYK.

Compression: Files can be reduced in size to conserve file storage space or decrease file transfer time. This is accomplished through one of three main compression schemes. Which are, lossless as with TIFF which uses LZW compression, lossy JPEG using DCT/Huffman and visually lossless as in the Photo-CD.

Constrain: Limits the changes made to a graphic in respect to its proportions or shape. If an image is resized and the dimensions are constrained, the software will allow size to change while the ratio of length to width remains the same.

Contact Image Sensor: A type of sensor that is smaller than a CCD, integrating fewer components and allowing a

Digital Photographic Imaging

more compact size. CIS scanners utilise LED's to produce white light. The product is a scanner that is thinner and lighter, more energy efficient and cheaper to manufacture than a traditional CCD-based device. Colour fidelity and image quality is not as good however.

Continuous Tone: Photographs are the best examples of continuous tone images, where brightness appears consistent and uninterrupted. An almost infinite number of tones within the extremes of minimum and maximum density are possible, whereas digital images compared to halftone, reproduce a finite number of discreet levels of tone.

Contouring: Poor conversion from 16 million to 256 colours will result in a banding-like effect of the colours and brightness. See also Banding.

Contrast: The measurement of the changes in brightness of an image. High contrast constitutes both dark black and bright white content.

Correlated Noise: The tendency of certain censors to produce a fixed-pattern of noise in an acquired image.

Coverage: The total image circle projected by a cameras lens upon the focal point.

CPU: Central Processing Unit. The primary chip in a computer where practically all data is processed.

CRT: Cathode Ray Tube. Otherwise known as the glass tube housed inside a computer monitor or Television set.

Curvature of Field: A lens that cannot produce a flat image of a flat field.

Digital Photographic Imaging

Curve: A graphical depiction of the colour and contrast of an image, as can be viewed by using a digital imaging application.

D

Dark Current: The current created by a CCD when no light is exposed. When insufficient light falls upon the CCD the current produced may be marginally higher than the Dark Current allowing for poor image quality (low signal to noise ratio). Also called Dark Voltage.

Data: The generic name for anything that inputs to, outputs from, or is stored in a computer in a digital manner.

DCS: Kodak's high-end Digital Camera System. This would be the professional line of digital cameras.

DCT: Discrete Cosine Transformation. An algorithm, which compresses an images data. The DCT method is used in the JPEG file format.

Default Setting: In computer software certain parameters come preset and they are automatically used unless changed by the user.

Density Range: See Dynamic Range.

Depth of Field: This is a zone of acceptable focus. DOF extends 1/3rd in front of, and 2/3rds beyond the point in focus. Double the f-stop and depth of field doubles (i.e. close the aperture two f-stops, f4 to f8). With an increase of subject distance, DOF increases; with a reduction of focal length, DOF increases.

Deskew: To make straight a crooked image, i.e. to line it up to a true horizontal or vertical axis on screen.

Digital Photographic Imaging

Diffraction: Different wavelengths of light bend with changes in density of the medium through which it is passing, and thereby reducing sharpness.

Diffusion Dithering: A method by which digitised images simulate many colours or shades with only a few by randomly allocating pixels instead of using a set pattern. See also Dithering.

Digital Camera: A device that uses a sensor to capture a visual image that can be processed by a computer. Digital cameras use the term Megapixel to measure the superiority of the camera. The Megapixel resolution is expressed as the number of horizontal pixels by the number of vertical pixels of an image (640 x 480, 1052 x 768, or 1280 x 1024 etc.) N.B. Essentially, the higher the resolution, the sharper the image.

Digital Imaging: The field of graphic design where computers are instrumental as the tool and the medium used to manipulate everything from digital photographs to medical diagnostics.

Digital Zoom: A method of zooming in on the centre of the sensor and reformatting the frame to the camera's full resolution. This method lacks the true clarity of lens optics as the camera is zooming in on a fixed number of pixels on the sensor to make a portion of the subject larger. This is a poor substitute for an optical zoom.

Digital: A manner in which information is stored, manipulated or produced by primarily using the binary code system.

Digitize: The method of converting analog data into a digital format for use in a computer environment.

Digital Photographic Imaging

Digitizing Tablet: A square surface which when combined with a pen-like device will allow on-screen control not unlike a pencil on paper. A point on the tablet represents a point-to-point association with the display screen. Control is much more fluid and refined than a mouse. This can be best illustrated by signing one's own signature with a mouse as compared to the stylus.

DIN: Deutsches Institut für Normung. The German Institute for Standardization provides services that support the development, distribution, and application of standards. See also <u>ASA</u>.

Disc: Term used to describe optical storage media (video disc, laser disc, compact disc), as opposed to magnetic storage systems.

Disk: Term used to describe magnetic storage media (floppy disk, diskette, hard disk), as opposed to optical storage systems.

Dithering: A process by which digitised images simulate many colours or shades with only a few. This is accomplished by alternating colours or patterns to create new colours and shades.

D-Max/ (Min): The maximum amount of density physically possible by a receiving medium.

Dot Gain: As dots of ink are applied to paper, the ink spreads and the dots increase in size.

Dot Matrix: An older printer technology that uses dots to create an image. Ink is transferred to paper by an array of pins striking a typewriter-like ribbon.

Digital Photographic Imaging

Dot Pitch: The distance between the centre dots of two adjacent pixel triads on a computer monitor. Used to compare the resolution quality among computer monitors.

Download: The transfer of digital information from one piece of equipment to another. As a hierarchy, this implies that the user is obtaining information from a principal source, See also <u>File Server</u>.

dpi (dots-per-inch): In a digitally perfect world, this would indicate a unit of linear measure that refers to the number of dots created by any output device within the distance of one inch (<u>resolution</u>), as opposed to <u>ppi</u> or lpi. The measure of an output device is based on dot density. Monitor, scanner & <u>printer resolution</u> vary widely due to the manner by which they interpret data. For example, laser printers have a resolution of at least 300 dpi, most monitors 72 dpi, most PostScript imagesetters 1200 to 2450 dpi, and scanners are anywhere from 300 to 1200 dpi. See also "<u>ppi (pixels-per-inch)</u>".

Drivers: Drivers are files that permit your computer to communicate with peripherals.

Drum Scanner: Scans are produced using photomultiplier tubes as opposed to CCD's. Typically they have a higher <u>dynamic range</u>, higher resolution and higher cost. This type of scan is considered a professional level benchmark.

Dye-based Ink: The typical ink available for the majority of printers on the market.
Water Resistance- This type of ink is water-soluble and typically has better flow characteristics. Unfortunately this dye will run if the paper is exposed to water.
Fade Resistance- The ink may be exposed to atmospheric contaminants and sunlight causing the ink to fade.

Digital Photographic Imaging

Dye-sublimation: Solid to a gas. Using heat and pressure, a thermal print head vaporises dye from a plastic ribbon, consisting of the CMY colours and a clear overcoat. The ink is then transferred to a special laminated printer paper.

Dynamic Range: A measured and quantified range from absolute black to absolute white that is given an assigned magnitude. The dynamic range of a device's imaging array is examined for its ability to capture a full range of shadows and highlights. Also known as brightness range, density range or D-max.

E

EI or Exposure Index: Any other "rating" which we give film or a digital camera above and beyond the given rating. See also ASA or ISO.

EPROM: Erasable Programmable Read Only Memory. A hardware based storage medium for images.

EPS: Encapsulated Postscript. A vector-based file format for postscript printers.

Ethernet: A type of computer networking system that allows multiple computers to be connected together.

EXIF: Exchangeable Image Format. A file format used in many consumer digital cameras.

Export: The process of transporting and converting data from one computer program to another. See also Import.

Exposure Value: A camera setting used to compensate for backlit subjects by overexposing (2X = +1 stop), or to compensate for front lit subjects (1/2X = -1stop).

Digital Photographic Imaging

Exposure: A combination of the amount of time a shutter is open in a lens or camera, and the diameter of the aperture admitting light onto a sensor. See also <u>Shutter Speed</u>.

F

Fading: This phenomena occurs to a displayed print during exposure to light or atmospheric contaminants, such as humidity, cigarette smoke or high levels of ozone. Predictions have been made on print fading due to displaying in the home. The permanence of the colours also depends on the colour intensity, colour range, and print media. Wilhelm Imaging Research Inc. has done extensive studies in this field.

FAQ: Frequently Asked Questions.

Feathering: Digital imaging applications soften hard edges within an image by "fading out" a number of pixels. If the edges of a pasted selection are rather sharp or coarse, feathering the selection could soften the edges, and the intensity of this feathering is variable.

Fibre Optics: An optical data transfer system that uses light for transmitting data through glass or transparent plastic fibres.

Field of View: The maximum area observable through a lens; it is as a rule measured in degrees.

FIF: Fractal Image Format. A particular file format whose compression scheme uses <u>fractal</u> mathematics.

File Format: A collection of information in the form of a data file saved on a disk. Common image file formats include <u>JPEG</u>, <u>BMP</u>, <u>TIF</u>, <u>GIF</u>, <u>PNG</u> and <u>EPS</u>.

Digital Photographic Imaging

File Server: A high-speed central computer in a network that serves as the primary storage component of a network and permits users to share its hard disks, storage space, files, etc. The distinction between a file server and an application server is that the file server stores programs and data, while the application server runs the programs and processes data. See also Host.

File Size Formula: Number of pixels (horizontal) multiplied by the number of pixels (Vertical) = Total number of pixels. Total number of pixels multiplied by the number of bits per colour divided by 8 = Total number of bytes. See also Image Size.

Fill Factor: The percentage of an imaging pixel that is actually capable of detecting light. Parts of a pixel are devoted to signal processing and data transfer. The percentage of the pixel that is devoted to imaging is called the fill factor.

Film Recorder: A device that is used to record a digital image onto photosensitive film, usually to produce a colour slide/transparency.

Filter: The software equivalent of a traditional optical filter, plus many more. These digital filters are available in-camera and in software. The advantages of software-based filters are that you are able to scroll through them all at leisure and to choose the intensity of the filter. There are two categories of filters; corrective and artistic.

Fire Wire: A system capable of high-speed data transfer with peripherals. IEEE 1394b can handle 3200 Mbps (megabits per second) and 63 devices. This type of computer interface is also hot swappable. See Hot-Swap. Developed by Apple Computer Inc. and Texas Instruments. May also be referred to as Lynx or I-Link.

Digital Photographic Imaging

Fixed Memory: Built-in, internal, non-removable flash memory that allows you to store images in the camera itself as opposed to storing images on removable cards or disks.

Flare: Stray light in an optical system caused by internal surface reflections.

Flash Cards: Removable memory cards capable of retaining data/images from a digital camera after the power has been turned off and the batteries have been removed or exhausted. Similar in size and appearance to a credit card but smaller.

Flash Markings: These markings are printed right on the camera. Typically an "X" flash synch (short for synchronize) signifies electronic flash. The shutter opens, followed by an instantaneous triggering of the flash. Infrequently an "F", "FP" or "M" indicates bulb, but mostly just "B". Originally the sequence was the flashbulb being fired first (the bulb gradually reaches peak intensity) then the shutter is fired. See also Flash Sync.

Flash Memory: A removable type of memory chip able to retain data after the power has been turned off. See also Flash Cards

FlashPix: Developed by Kodak, Live Picture, Microsoft and Hewlett Packard. This is a multi-resolution file format in which the image is stored as a series of independent arrays. File size is larger than TIFF, but requires less RAM for viewing. Some imaging programs require a plug-in for this format. See also Photo CD.

Flatbed Scanner: An optical scanning device where the scanned material is held flat rather than being wrapped around a drum. The original image remains stationary while the sensors pass under it, using a linear array CCD.

Digital Photographic Imaging

Used for both reflective and transparency materials. See also <u>Contact Image Sensor</u>.

Floppy Disk: The name given to a removable 3.5-inch disk (previously 5.25") used for magnetically storing relatively small amounts of computer data, typically 1.44 Mb.

Focal Length (F): The distance from the <u>principal point</u> of a lens to the <u>focal point</u>. In other words, when a lens focuses the image of a distant subject upon a surface, the distance from the optical centre of the lens to the surface (<u>Focal Plane</u>) is called the focal length (while focused at infinity ∞).

Focal Plane: The surface area where an image is focused. Also known as the image plane.

Focal Point: The furthest point whereupon light rays passing through a lens are focused. See also <u>focal plane</u>.

Focusing Screen: An opaque screen that is placed at the <u>focal plane</u> of a camera, providing a visual representation to the photographer as an aid in framing and focusing on an object. The image that is shown on the screen is the same as the image that will be captured.

FPO: For Position Only. A low-resolution representation of an image used for arrangement in a document.

Fractal: Used to describe a category of geometric shapes, characterized by an irregularity in shape and design that can be repeatedly subdivided into parts, each of which is a smaller copy of the whole.

f-Stop: The ratio of a lens' focal length (at ∞) to the widest opening of the aperture of the lens. Also known as the speed of a lens. This rating is obtained by dividing the <u>focal length</u> by the aperture's maximum diameter at

infinity. (e.g. A 50mm lens with an aperture of 25mm is rated at f-2.)

Full Bleed: An image or area of solid colour that extends to all edges of the printed paper. See also Bleed.

G

Gain: The amount of signal amplification in an electronic device. Increasing a digital camera's gain control will boost the contrast and therefore the brightness of the image.

Gamma: This is the association between input from a digital image and the output instructing the monitor how to display the graphic. Also referred to as an advanced image-editing step, where gamma correction lets you modify an image's level of brightness. Changing the gamma setting with the scanner's software or in your imaging program brightens or darkens an image. Lastly, for film this is a measurement of the relationship existing between the contrast of a negative and the contrast of a scene.

Gamut: The complete range of colours that can be displayed or printed on a specific colour system. If your computer monitor were displaying its maximum assortment of colours possible, you would consider it to be showing its full gamut.

Generation: A copy of a file, out of a series of files. Analog storage is prone to loss, while digital is lossless.

Ghosting: The rendering of a faint second image caused by an internal reflection transferred onto the CCD. By scanning any white square or circle and then zooming in closely, you can see the ghost falling outside the bounds of the circle on a scanner that has this problem.

Digital Photographic Imaging

Giclee: ("jhee-CLAY") is the French word for "spray." The giclee print is essentially a high quality ink jet print. The giclee process, on the other hand, produces an archival print through the use of light-fast inks and acid-free fine art papers.

GIF / GIF 89a: Graphics Interchange Format, owned by CompuServe and introduced in 1987. A bit-mapped raster graphic file format popular for storing lower resolution image data. GIF's utilise <u>indexed colour</u>, that is 256 colours (<u>8-bit</u>) and transparent backgrounds for use in web applications. GIF's are cross platform compatible. The compression scheme is <u>LZW</u>, making the file size smaller and therefore easily viewable. An <u>interlaced</u> GIF is a web graphic downloaded initially at a low resolution and progressively gets better as more data is received. The 89a designation refers to the latest version of GIF, which incorporates transparency, interlacing and animation.

Gigabyte (GB): A quantity of computer memory or disk space. Equal to approximately one thousand megabytes. The actual value is 1,073,741,824 bytes (1024 megabytes).

GIMP: Gnu Image Manipulation Program. A freely distributed piece of software suitable for such tasks as photo retouching, image composition and image altering. Largely utilised in the environment of a Linux operating system, although it has branched out to others.

Glossary: A collection of specialized terms with their meanings.

Grain: The granular appearance of a scanned photograph or negative. This is not caused by individual silver particles in the films emulsion, but rather the extent to which they "clump" together. The digital equivalent of this is referred to as <u>noise</u>.

© 1999 Phil Taylor

Digital Photographic Imaging

Graphic: A photograph, two-dimensional representation of an object, artwork or illustration.

Grey Level: Pixel brightness. This is the representation of a pixel's lightness value from black (0) to white (255).

Greyscale: An image encompassing shades of grey as well as black and white.

GUI: Graphical User Interface. A computer interface such as the Apple Computer Inc., Mac OS, Microsoft Windows and Linux, which use graphical icons to represent computer functions.

H

Halftone: A process where a continuous tone graphic has been "screened" to break it into black dots of varying sizes to simulate shades of grey. Normally used for newspapers or magazines. Halftoning or screening must be done to make the job camera-ready.

Hardcopy Proof: An actual print out, usually in draft quality.

HDTV: High Definition Television. This acronym refers to a new aspect ratio (16 to 9) used for both television and Kodak's new Advanced Photo System.

High Colour: A display or system that uses 16 bits of colour data to represent each pixel or 65,536 possible colours. See also 16-bit colour.

Highlight: The brightest portion of an image, excluding specular highlights.

Histogram: A chart, which shows the tonal variations and dynamic range within an image, while working in a digital

imaging application. An image's grey levels from highlights to shadows are represented graphically, usually as a bar chart. The pixel brightness values are displayed across the horizontal axis. The quantity of these pixels would be represented by the vertical axis.

HMI: Hydrargyrum Medium Arc Iodide. A specialized type of light source, which is continuous, flicker free, and recommended for certain digital cameras.

Host: Computer hosting server software.

Hot-Swap: The ability to plug in or unplug a device from one's computer without having to shut down the system. An example of a connection that is unable to do this is the Parallel Port. See also Firewire.

HSL & HSB: Hue, Saturation and Luminance (Brightness); the three elements of colour. See also chrominance.

HTML: Hyper Text Mark-up Language. This type of data is the basis for webpage design.

Hue: A component of colour, specified by the name of the tint (i.e. red). See chrominance.

Hyperfocal Distance: When a lens is focused at this distance it creates a zone of sharpness, from infinity to the nearest object in acceptable focus. This distance delivers maximum depth of field including infinity, for a lens not focused at infinity.

Hyper-Link: Text or an image which if clicked will take you to another location within an electronic document or on the World Wide Web. This glossary uses hyper-links extensively to allow you to quickly move from definition to definition.

I

ICC: International Colour Consortium (Est.1993). A group of eight computer and digital imaging manufacturers who worked to develop the standardisation of a non-proprietary, cross-platform, colour management system and profile.

Icon: A small graphic symbol or picture on a computer screen that represents a file, folder, disk, or command as used in a GUI.

IEEE: Institute of Electrical and Electronics Engineers. The IEEE 802 is a standard for local-area networks.

Image Pac: A multi-resolution image file format developed as part of the Photo CD System.

Image Processing: The process of digitally capturing images in order to enhance, manipulate or gather data.

Image Resolution: The number of pixels per unit length of image. For example, pixels per inch, pixels per centimetre or dots per inch (dpi). This is known as spatial resolution. See also Resolution.

Image Size: Number of pixels (horizontal) multiplied by the number of pixels (Vertical) = total number of pixels. Total number of pixels multiplied by the number of bits per colour divided by 8 = Total number of bytes. Also known as a file size formula. When image size is doubled, this generally does not refer to area. Doubling a 4x6 image produces an 8x12 inch image.

Image: A visual scene represented by the pixels of a monitor, droplets of ink on paper or digitally where the images are stored electronically as bits of data.

Digital Photographic Imaging

Import: The process of converting or transferring data within a program from another computer program. See also <u>Export</u>.

Inch: A unit of measurement equal to six (6) <u>picas</u> or seventy-two (72) <u>points</u>.

Indexed Colour: A single-channel image with <u>8 bits</u> of colour information per pixel. The index is a <u>CLUT</u> containing up to 256 colours or less. This range of colours can be edited to include only those found within the image.

Infrared: In the spectrum of light, it exists as wavelengths longer than those of visible light. Its predominant use is for wireless instruments, such as palm-type devices communicating with laptop or desktop computers.

Ink-Jet Printer: A printer that produces text and images out of dots of ink. The dots are formed by jets of ink being sprayed to paper.

Intensity: The quantity of light reflected or transmitted by an object. Black would be the lowest intensity and white the highest.

Interface: The physical means by which a device connects to and transmits data to a computer. Typical interfaces are through the computer's <u>USB</u> port, <u>serial port</u>, <u>Firewire</u>, <u>parallel port</u>, or through use of <u>PCMCIA</u> and <u>CF cards</u>.

Interlaced: A web graphic that is downloaded by your browser, initially at a low resolution and improves progressively as more data is received. See also <u>GIF</u>.

Interpolation: A method for increasing the apparent <u>resolution</u> or size of an image whereby the software mathematically averages adjacent pixel densities and colours and places a pixel of that value in the image. This

may be used where a scanner is unable (due to its own technical/physical limitations) to sample the additional data required from the original graphic.

IrDA: Infrared Data Association. An association of manufacturers that have developed a standard for transmitting data via infrared light waves.

ISDN: Integrated Services Digital Network. A telecommunications standard allowing digital information of all types to be transmitted via standard telephone lines.

ISO 9660: A file format implemented for CD-ROM's. Among other things this allows cross platform compatibility.

ISO Speed (ASA/DIN): International Standards Organisation. The rating applied to photographic emulsions to denote their relative sensitivity to light. The CCDs in digital cameras have 'equivalent' ISO ratings to ensure an easy transition from film. See also ASA or DIN.

IT8: An industry standard colour reference chart used to help calibrate scanners and printing devices.

IVUE: Live Picture's own proprietary file format. By only accessing the required data for your screen size and zoom factor, this allows images to be displayed quickly.

J

Jaggies: A serrated stair-stepping effect seen in raster graphics especially on diagonal lines. See also Aliasing.

JFIF: JPEG File Interchange Format.

JPEG or JPG: Joint Photographic Experts Group. A graphic file format, which uses a combination of Discrete

Cosine Transformation (DCT) and Huffman encoding. The image is divided into 8x8 blocks and then a DCT is executed on these blocks to transform the data into frequency space. JPEG is a lossy compression file format that compresses up to 20 to 1. It relies on the fact that we are more perceptive to luminance than to chrominance. The image is separated into these two categories and compresses the chrominance. The medium setting and above inflicts the least loss. Keep in mind that when you are saving as JPEG, the 100% setting still compresses. When you have a JPEG that needs repeated editing, convert it to the program's <u>native</u> format or at least a TIF, and then work on it. The compression factor of JPEG is compounded and causes image degradation if you save, close and then re-open the image repeatedly. JPEG files for the web have more appeal when saved as <u>progressive</u> JPEG's. These graphics are downloaded initially at a low resolution and progressively get better as more data is received. The GIF equivalent is referred to as <u>interlaced</u>.

K

K / Key: The letter "K" in CMYK. "K" as in blac*k*.

Kbps: Kilobits per second. The measurement of the data transfer speed. <u>Modems,</u> for example, are measured in *Kbps*. One Kbps is 1,000 bits per second, whereas a *KB* (kilobyte) is 1,024 bytes. Data transfer rates are measured using the decimal meaning of *K*, whereas data storage is measured using the powers-of-2. *kbps* should be spelled with a lowercase *k*

Kilobyte (KB): This represents 1024 bytes.

L

Lambda Print: A print that is produced at a photo quality level, utilizing traditional photographic paper. The printing process is a continuous motion procedure where RGB lasers shoot a beam through a prism/mirror combination. Prints are produced in two fashions, one is a larger format at 200ppi and the other is a smaller format at 400 ppi. These are <u>continuous tone</u> prints.

LAN: Local Area Network. A network of computers that are linked by cables, enabling them to exchange files and share peripherals.

Laser Printer: A technology that uses a laser to charge an electrostatically sensitive drum which then attracts a carbon-based toner. The toner is then fused to the paper.

LCD: Liquid Crystal Display. A flat panel of tiny cells used on mobile computers, palm computing devices, and many consumer digital cameras to display information on camera activities and status. A digital cameras' LCD is also used for composing and previewing images.

Leading: The space between lines of text, usually measured in <u>points</u>.

LED: Light Emitting Diode. This is another method of producing a print by exposing light sensitive paper. See also <u>Photograph</u>.

Lens Contrast: This relates to the reduction of reflection and flare. In turn, this decreases the effective contrast.

Lightfastness: The measured ability of any media to resist prolonged exposure to light.

Digital Photographic Imaging

Lignin: An amorphous organic polymer (related to cellulose) founding the cell walls of many plants. A Lignin-free paper enclosure is recommended for proper photograph storage as Lignin that is left in pulp causes paper to age and yellow over time.

Linear-Array: A class of CCD where the elements are positioned in a row (a vector), as used in flatbed scanners. A single pass scanner requires that the array have three rows of sensors. One row each for red, green & blue. A triple pass scanner scans an image three times, each time using RGB filtering for each respective colour.

Lossless Compression: Reduces the size of files and retains the structure of the data as it was prior to the compression. This is also known as being non-destructive to the image data. See also TIFF.

Lossy Compression: A compression scheme that reduces image file size by discarding some data, resulting in a perceptible loss of image quality. The degree of loss is dependant on the level of compression, quality of output and the viewer (See Subjective Evaluation). JPEG is the file format most often associated with this compression.

Low Key: A graphic who's tonal range consists mostly of dark values (shadow).

LPI: Lines-Per-Inch. Refers to the lines on the screen that is used to create halftones in the graphic arts industry. An lpi figure is used to specify a course (60lpi) or fine (120lpi) screen for both hard copy and digital images eventually going onto the printing press. For conversion you should double the lpi to get the equivalent dpi.

Luminance (Luminosity): The brightness of a colour, measured in lumens.

LUT: Look Up Table. Sometimes called a Colour Look Up Table or <u>CLUT</u>.

Lux: A unit used to measure light intensity. Represented by the illumination of a surface by a single candle.

LZW: Lempel-Ziv-Welch. A more refined version of the <u>RLE</u> lossless compression scheme. Produces a compression ratio of 10-1 in one pass and is useful for large areas of single colour. Used in the <u>GIF</u> and <u>TIFF</u> format.

M

mAh: This provides an indication of how long a device will operate. The amount of charge in a battery that will allow one ampere of current to flow for one hour (milliampere hour).

Marie Curie: "Nothing in life is to be feared. It is only to be understood"

Mask: A distinct area that is separated from the rest of an image to protect that area from alterations. This process was also used in the past when using dry dyes for retouching. Brushing on a masking liquid protected the areas not requiring to be dyed. Out-of-reach inner parts did not need to be covered, but the edges had to be precise. It is also similar to lith masking in an enlarger.

Matrix: A two-dimensional array consisting of rows and columns. See also <u>The Matrix</u>.

Media: The materials on or in which images are stored and/or displayed.

Medium: A specific manner of visual expression as determined by the materials, tools, and techniques for creating and reproducing images.

Digital Photographic Imaging

Megabit (Mb): A quantity of digital data measuring 1 048 576 bits.

Megabyte (MB): An amount of computer memory consisting of about one million bytes. One MB equals 1 024 kilobytes or 1 048 576 bytes

Megahertz (MHz): A measure of frequency usually associated with processor speed and calculated at 1 million cycles per second.

Megapixel: One million-pixels. Although, more accurately measured at 1 048 576 pixels. In respect to digital cameras, having a greater number of pixels means a superior level of quality in the images you are capturing.

Memory Card: A small card used for the storage of image data captured by a digital camera.

Metafile: This file format accommodates both vector and raster data. Apple's Pict file format is a metafile.

Metal Oxide Semiconductor: There are several varieties of MOS technologies, including PMOS, NMOS and CMOS.

Microdrive: A micro-miniature high-capacity disk drive that is slightly thicker than a CompactFlash card. Microdrive conforms to the CF+ II standard.

Modem: A device for converting digital signals into analogue for transmission over standard telephone lines and then back to digital. (MODulator / DEModulator)

Moiré: An image defect caused by interference between a pattern on a document and the sampling frequency of the scanning device (undersampling). Also, when halftone screens are misregistered a visible pattern occurs.

Digital Photographic Imaging

Mottle: A defect in matrix colour printing which causes irregular print density or uneven colour, forming part of an irregular pattern.

MPG or MPEG: Motion Picture Experts Group. Like JPEG, a standard compression routine is used for video, audio and animation sequences. This format is a widely accepted method of compressing these files into a smaller file size.

Multimedia: The amalgamation of various media, such as sound, text, graphics, video and still photography into an integrated package.

Multitasking: Working on several tasks or using multiple programs or applications at the same time.

N

Native: This refers to the source or originating application of a unique file format, graphic or other output.

Network: An interconnecting group of computers that can communicate with each other to share resources and peripherals.

Nibble: This is equivalent to half a byte, which is 4 bits.

NiCD: Nickel-cadmium. A type of rechargeable battery that is used to power some digital cameras.

NiMH: Nickel Metal Hydride batteries are rechargeable, but do not experience the "memory" effect associated with other rechargeable battery technologies. This is becoming an increasing popular power source for consumer digital cameras.

Digital Photographic Imaging

Noise: Mostly an analog problem. Generally it is represented as random, incorrectly read pixel data, or an extraneous signal generated by a CCD, even when no light is falling on it. This "snow" may be caused by electrical interference and is established as the noise level of the system. See <u>Signal to Noise Ratio</u>. Shadow detail can be greatly affected by this.

Non-Volatile Memory: Memory retention without a constant power source. ROM's, PROM's, EPROM's and flash memory are examples. See also <u>Volatile Memory</u>.

Normal Lens: A lens, which has a focal length that corresponds to the diagonal field of view of the <u>focal plane</u>. For 35mm film this would be a 43mm lens, (which produces a 52-degree <u>field of view</u>), where the focal length equals the diagonal of a single frame of a particular film format.

Nyquist Frequency: The highest frequency that can be sampled by a scanner, measured at 1/2 the sampling rate of the device.

O

Object (3-D): A 3-D object is a set of instructions that a rendering or ray-tracing program uses to draw a complex image. It allows the artist to change angles, light, and so on without re-drawing the image. The object is a set of parameters, not a picture. See also <u>Render</u>.

Object Oriented: A graphics application that uses mathematical points based on <u>vectors</u> to define lines and shapes. Vector graphics are resolution independent in that they may be output at any size with the final quality dependent solely on the resolution of the output device.

Digital Photographic Imaging

Objective Evaluation: An Image whose properties and parameters are technically evaluated. See also <u>Subjective Evaluation</u>.

OCR: Optical Character Recognition. A printed text document that is scanned and then processed through software can be converted into a file format recognisable by a word processor. Accuracy relies entirely on the software's ability to recognise the text.

OEM: Original Equipment Manufacturer. This refers to a manufacturer that produces and sells equipment to a reseller. Also refers to the reseller itself.

OLE: Object Linking and Embedding. The standardised combination of data from various applications.

On-board Processing: The ability to accept data and process it locally, as opposed to sending the data to another processor on another physical device.

Opaque: Solid colour you cannot see through nor pass light through.

Optical Axis: An imaginary line passing through the centre of a radially symmetrical optical system.

Optical Frequency Response: This is the scanner's ability to capture a certain frequency.

Optical Resolution: The measure of the true ability of an optical system to resolve a scene or object, often measured in line pairs per millimetre. This measures or indicates the "true" resolution of a device. See also <u>Resolution</u>.

Optical Zoom: The capability of zooming in on a subject using the lens exclusively. The lens focuses an image upon a sensor with a fixed resolution. When zooming in on a subject, the subject is enlarged and will be represented on

Digital Photographic Imaging

the sensor by the same fixed resolution without interpolation. A digital zoom crops a portion of the sensor and then formats to the camera's resolution.

OS: Operating System. This system determines the platform running on a computer. The software that is installed on your computer before all else, to run the traditional programs you will use for word processing and graphics editing.

Oversampling: When a device is configured to scan a target at a sampling rate greater than its optimum settings. Visibly noticeable as an overly large filesize. See also Subsampling.

P

Panchromatic: Having sensitivity to all colours of light.

Parallel Port: This is most often used for connecting printers to computers, although it may also be used for other external devices such as tape drives or CD Burners. Parallel ports have eight parallel wires, which send 8 bits (1 byte) of information simultaneously in the same amount of time that it takes a serial port to send a single bit. Also known as a Centronics port.

Parity: A form of error checking when transmitting or storing data.

PC Card: Otherwise known as PCMCIA card. A removable credit-card sized circuit offering certain functions such as a modem, network card, or memory storage for captured images. These cards provide an easy interface to notebook computers and PCs equipped with card readers. The PCMCIA standard has three types- type I cards are 3mm in thickness, type II cards are 5.5 mm, and

type III cards are 10 mm. Types II and I will fit into the Type III socket.

PC: Personal Computer.

PCD: The file format used by Kodak's Photo CD.

PCMCIA Card: Personal Computer Memory Card International Association. This is the formal technical acronym for what are now commonly known as PC Cards.

PCX: Originally developed for PC Paintbrush. Commonly seen in clipart from both MS-DOS and Windows-based programs. Most of today's graphics packages, shareware, and commercial programs can read or convert these formats.

PDD: Adobe Photo Deluxe file format. A cross-platform file that will retain all layers and allows multiple programs to open it.

PDF: Portable Document Format. The file format used by Adobe Acrobat and Acrobat Reader. Acrobat allows the creation of a document file that retains the look of the original. The distributed document can then be viewed with Acrobat Reader.

PDL: Page Description Language. A set of instructions that relays information to the output device relating to the placement of images, text and other data. See also PostScript.

Peripheral: A term used to collectively describe computer hardware accessories such as printers, modems, scanners, and digital cameras.

Perspective: The appearance of a subject with respect to their relative distance and position to the camera. Changing a lens alone will not change perspective, it only

Digital Photographic Imaging

alters the appearance by compressing (telephoto) or expanding (wide angle) distance.

Photo CD: Kodak's proprietary system for recording film images onto a CD. One image is stored at 5 different resolutions in the file format PCD. Frequency colour and luminance compression are applied to an image. Unfortunately, the maximum dynamic range of a Photo CD scan is limited, although this should improve. Kodak utilises the YCC colour model. See also FlashPix.

Photograph: Also to be known as a photo, and will be referred to as a graphic produced by traditional photographic means. The distinction between a print and a photograph is blurred by graphics that are "printed" or "produced" by laser or LED's.

Photographic: Any graphic created by the action of light on a light sensitive material or sensor.

Photometer: A device for calibrating a computer system to ensure that what you scan will look the same as what is printed out in the end. Measuring the luminosity of the scanned graphic, the monitor and the final print does this. The calibration of all three will ensure as close a match as possible.

Pica: A unit of measurement equal to twelve (12) points or one sixth (1/6) of an inch. Normally used in layout work to measure column widths, gutters and headings.

PICT: The Apple Macintosh platform's file format for a relatively low-resolution bitmap image. Images cannot be scaled to another size without loss of detail. PICT files can contain both object-oriented and bit-mapped graphics. There are two types, PICT II and I. PICT II supports colour up to 24-bit. See also Metafile.

Digital Photographic Imaging

Picture Disk: A lower end option to the Photo CD and traditional photo finishing. The Picture Disk is a 3.5-inch floppy that holds up to 28 pictures at a single resolution of 512 x 768 pixels.

Picture Element: The smallest discreet component of a digitally produced image. The images on your computer screen are made up of thousands of individual photosensitive cells otherwise known as pixels.

Pigment: A substance that is added to give inks their colour, as opposed to the addition of dyes. Pigments are often in the form of dry powders suspended in a base solution. The reflection or absorption of light by these particles determines its colour (carbon is commonly used as a component for black.). Generally, dye-based ink has better "image quality" and the pigment-based inks have their strength in "longevity".

Water Resistance- Pigments do not dissolve completely, so the particles tend to settle into the tiny fibres that make up the paper. As the ink dries, the pigment particles get stuck in the fibres. Thus, the pigmented inks are more water resistant than the dye-based inks. Only about 5 to 10 percent of the ink will re-flow if the paper is exposed to water.

Fade Resistance- It is much more difficult for sunlight and chemicals to react with all of the pigment molecules, since most of them are embedded within the structure of the medium it is printed on. Pigmented inks will usually last for many years before fading becomes noticeable.

Print Quality- It is possible to get more "colour" into pigments than into dyes. Therefore, pigmented colours tend to be more vibrant than dye-based colours, and pigmented black inks tend to be slightly darker than dye-based inks. The small particle size also allows sharper image detail.

Digital Photographic Imaging

PIM: Print Image Matching. A system devised by Epson that maintains a standardised progression from digital camera to printer. When an image is captured in a PIM digital camera, information is imbedded in the image file. This information may include <u>gamma</u>, colour space, contrast, sharpness, brightness, saturation, colour balance, shadow point and highlight point. When used in conjunction with a PIM enabled printer, results are matched with the digital camera's PIM information. This is very optimistic and warrants some attention at this time.

Pixel Depth: The amount of data used to describe each coloured dot on the computer screen. See also <u>Bit Depth</u>.

Pixel: Short for <u>picture element</u>. The smallest point capable of resolving detail. The digital equivalent to the grain of film. A pixel on a computer monitor is made up of an RGB triad. In other words, three points coloured red, green and blue comprise one pixel. When these pixels are of equal intensity they generate white. See also <u>Additive Colours</u>.

Pixellation: The impairment of an image, in which the pixels are large enough to become individually visible. See also <u>Jaggies</u>.

Platform: The <u>O.S.</u>, hardware, software or chipset architecture determines the platform. (E.g. A machine (IBM, Apple) running the Linux OS.)

Plug and Play: Ability of an operating system to identify a <u>peripheral</u> (modem, monitor or display) and to automatically configure the system to incorporate the device. Also known as PnP.

Plug-In: Third part applications that are utilised from within your imaging software in the form of filters, edges,

Digital Photographic Imaging

etc. These sub-applications add to the functionality of a program.

PMT (Photomultiplier Tube): A device that performs the function of converting light into electrical energy and them amplifying it. These particular tubes are utilised in drum scanners, due to their increased sensitivity in comparison to a CCD.

PNG: Portable Network Graphics. A file format utilising lossless compression and breaking ground on the World Wide Web, thought it has not yet gained the popularity of GIF or JPEG files. PNG really has three main advantages over GIF – alpha channels (variable transparency), gamma correction (cross-platform control of image brightness), and two-dimensional interlacing (a method of progressive display). PNG's also compress better than a GIF in almost every case, but the difference is generally only around 5% to 25% -s not a large enough factor to encourage switching on that basis alone. One GIF feature that PNG does *not* try to reproduce is multiple-image support, especially animations. PNG is intended to be a single-image format only. GIF supports simple transparency, in that any given pixel can be either fully transparent or fully opaque, whereas PNG allows up to 254 levels of partial transparency. See www.libpng.org/pub/png/.

Point: A unit of measurement equal to 1/12 of a picas or 1/72 of an inch. Normally used to measure type size and leading.

Polarizer: An optical filter that is placed in front of a camera's lens to reduce a surface's reflection or to increase colour saturation. The most common effect that people have been known to use this filter for is to alter the appearance of the sky. The maximum effect occurs in a clear sky at right angles to the sun's rays.

Digital Photographic Imaging

Posterization: The process of separating an image's colours or shades into discrete areas of brightness and then changing those regions to a solid shade. See also Banding.

Postscript: A programming language developed by Adobe Systems Inc. that describes the appearance of graphics and text on a printed page. See also PDL.

ppi (pixels-per-inch): This term is often confused with dpi, and refers to the spatial resolution of any image in digital form, within a computing device. See also dpi (dots-per-inch).

Press Proof: A sample of an actual project that has been printed on the anticipated paper stock. This is the most expensive and accurate form of output, and for this reason there are very few copies made.

Primary Colours: Red, Green, and Blue. The colours used to simulate natural colour on computer monitors and television sets. See also Additive Colour.

Principal Plane (Optics): Two planes perpendicular to the optical axis (See also Focal Length.)

Principal Point (Optics): The intersection of a principal plane with the optical axis.

Print: The typical output from a printer, which produces a graphic through a computer interface. This term also applies to text, although not used as such within this glossary.

Printer Resolution: The manner in which the resolution is measured for output devices is unlike that of scanners. Each of the 16 million colours cannot be represented by a single dot of ink (measured in Pico-litres). Generally each image pixel is represented by a combination or mixture of

Digital Photographic Imaging

colour through a process referred to as <u>dithering</u>. The resolution of your printer is not directly related to the <u>resolution</u> of your scanner. You don't need to scan an image at the same resolution that the printer prints at. As a rule of thumb, set the scan resolution at 1/3rd of the desired printer's resolution.

Processing: With regard to digital imaging, the stage of image production in which input image data is transformed into output image data. Processing would include the transformations of geometry (shape), resolution, tone, or perhaps colour of an image.

Progressive: Graphics that are downloaded initially at a low resolution and then go through a gradual transition of improved resolution as more data is received. See also <u>JPEG</u>.

Proof: Output intended to simulate the final product of an image production process for the purpose of approval. A hardcopy proof is an actual print out of some sort. In <u>soft proofing</u> the image is viewed on a monitor set up to emulate the final output as closely as possible.

Pure Images: Digital images that contain "pure" or "<u>raw</u>" image data that has not been compressed or modified in any way. Pure images may, however, be encoded in a lossless mode for purposes of efficient data storage.

Push: This refers to altering a cameras ideal ASA rating to another setting <u>E.I.</u> to perhaps better suit current lighting conditions.

Digital Photographic Imaging

Q

Quality of light: A light source generally falls into one of these two categories.
Hard light- Sources are small and harsh relative to the size of the subject, akin to a sunny day. The sun may physically be very large, but due to its distance and our perspective it may as well be a bright light bulb hanging from the ceiling. The harshness is evident in the stark contrast of the shadows that are cast upon the subject.
Soft light- Sources are large and diffused relative to the subject, comparable to an overcast day. The clouds tend to scatter the sunlight so it falls upon the subject from various angles, thus reducing contrasts.

Quantization: A process of placing a value upon similar chrominance or brightness levels, then grouping pixels of comparable levels together as one. This is done for compression purposes or simply to reduce the number of colours to match a particular colour set for a particular file format.

R

RAM: Random Access Memory. When a computer is turned off, the contents of the memory are lost, as opposed to ROM. This particular type of storage is thus considered volatile memory. Generally, with a greater amount of RAM, image manipulation and background processing is improved.

Raster: Raster images are made up of a grid of individual pixels. Each individual pixel contains a value that determines its colour, size and location within the image. Also known as bitmapped images.

Digital Photographic Imaging

Raw Image: An unprocessed digital image that contains all of the original sensor pixel data. Raw image data is the purest form of sensor data. The raw data must be processed into a standard image file format for viewing. See also Pure Image.

Ray Tracing: A rendered or 3D image. An image generated automatically by a computer program from a set of instructions rather than from the input of a mouse or drawing device. The creation of a rendered image is a time-consuming process.

Real Time Image Processing: A data processing system that responds immediately to the user, processing each function immediately and displaying it at a high enough resolution to be viewed.

Reciprocity Effect: The ability of a photosensitive material to follow the rules of accumulating light purely mathematically. In a typical range of exposures, say from $1/15^{th}$ of a second up to perhaps $1/4000^{th}$ of a second, a proper exposure can be made. Beyond the previously mentioned range, complications may arise. See also Reciprocity Failure.

Reciprocity Failure: When an extended exposure is made according to conventional calculations, the exposure will be incorrect. This is more common during exposures in excess of one second. The predominant faults observed are contrast changes and colour shifts.

Rectilinear: Formed from or consisting of straight lines

Redo: If a mistake occurs during the modification of a digital file, the last error can usually be undone by single keystroke. If this occurs, the undo can also be reversed by the redo command.

Digital Photographic Imaging

Reflectance: The portion of light that is reflected off a surface. Reflectance varies according to the wavelength of the light.

Reflective Art: Non-transparent artwork that relies on the reflection of light to present colour, texture, tonality and form.

Refraction: The bending of light rays as light passes from one medium to another, where the two materials are of different density.

Refresh Rate: The frequency at which the image on your screen is refreshed, measured in Hz. The faster the rate, the more stable and flicker-free an image will appear on the screen. This helps to reduce eyestrain.

Registration: Precise overlapping of the three colour channels in a scanned image. Also refers to the alignment of different coloured inks in the printing stage.

Removable Media: This is a broad, general category that includes any data storage device that can be physically removed from a computer or computing device. This can include PC cards, floppy disks, CD-R, CD-RW, CompactFlash, Click!, Smart Media, Multimedia cards, tapes, Zip or Jaz disks, and many others.

Render: The finishing step of an image transformation through which a new image is refreshed on the screen. The addition of texture to a wireframe to create an authentic looking representation.

Resample: A method of changing the resolution of your image either by removing unwanted pixels or adding them through the process of interpolation. Resampling adjusts the image size in pixels.

Digital Photographic Imaging

Resin Coated Paper: A paper that utilises the same base as real photo paper. This form of paper will not ripple when wet, as a result of the base. There is a long drying time; although once dry it will maintain its original appearance.

Resize: To alter the resolution, or the horizontal and/or vertical size of an image.

Resolution: The longest definition so far. Resolution generally refers to the pixel density within in a graphic of certain dimensions. One thing to keep in mind is that the math is just a recipe, and understanding the relationships between the three components of the resolution circle is the key to it all. Resolution is determined by the number of dots per inch or pixels per inch in an image, calculated from the centre-to-centre spacing between each dot. For example, an early digital camera could produce a 640x480 image with a product of 307 200 pixels, thus designating it as a 0.3 megapixel camera. If the number of pixels within an image is fixed, increasing or decreasing the image size (resizing) will alter the resolution. Consider that an image's resolution is established by viewing a series of closely spaced horizontal and vertical lines that must not be broken or touching each other. Resolution is determined by the minimum distance between two lines, and yet ensuring them to be two separate items. When purchasing a scanner, optical resolution is an important specification. A particular scanner may be 600x1200 dpi; the first number indicates the optical resolution and the second denotes the fine movements of the scanner's stepping motor that moves the CCD array. This same scanner may be rated as 1200x1200 dpi. The additional resolution is simulated through

interpolation. You would be hard pressed to detect any difference. Printer Resolution is another definition on its own. A typical misconception about resolution, in relation to the process of scanning is, "the greater the scanning resolution the greater the sharpness or clarity of the final scan." This is untrue, due to the fact that there is only so much information that can be acquired before it is redundant. The "Resolution Triad" depicted is the summation of resolution, and can be reduced to P=IR , R=P/I or I=P/R. You can do the math! See also Rules of Sharpness.

Resolving Power: The proficiency of a film, lens or imaging system to produce distinct and noticeably fine detail. This figure is measured by a device's capability of maintaining the separation of closely spaced fine lines, expressed as "line pairs per millimetre", visible in an image of a test chart produced by the system.

RGB Filters: Imaging sensors do not detect colour, they only respond to the intensity of light. Through the process of filtering each of the colours, red, green and blue are sampled and then combined with their particular intensities to produce a correct graphic.

RGB: Red, Green, and Blue. These are the primary colours used to replicate real-life colour on computer monitors. See also Additive Colour.

RIP: Raster Image Processor. The process of converting object-oriented graphics and text into the data required for output on a printer. Rip is also known as the process of extracting audio from a music CD in a computer.

RLE: Run Length Encoding. A lossless compression scheme that requires one pass to read the data and make a table, and a second pass to compress. Used in the Huffman compression scheme, and in the GIF and TIFF format.

Digital Photographic Imaging

ROM: Read Only Memory. This type of memory is fixed and cannot be changed, not unlike a CD-ROM. ROM is non-volatile and will not be altered once its power supply is turned off.

Rules of Sharpness: There are three phases of sharpness. Firstly, a 4x6 inch image scanned at 300dpi and then printed at 100% would produce a photo-real print. That same image scanned at 600dpi and then printed at 100% would produce the same quality print – but this print could be scaled up to 200% and would create an 8x12 inch print. Secondly, the example 4x6 inch print can be scanned at 150dpi and then printed out at 100%, producing a print of low quality. Pixellation may be evident by close inspection, but apparent sharpness improves when viewing distance increases. Thirdly, the 150dpi, 4x6 inch print in the second example could be sampled up (interpolated) to 300dpi, to produce a low quality 4x6 inch print at 300dpi. There is less pixellation evident so this adds to the fineness of the print. Also, the perception of the quality is relative to viewing distance. In relation to the print in the second and third examples, each of the prints could have been printed at 50% to produce a photo-quality print. See also Resolution.

Digital Photographic Imaging

S

Sample: A discreet component or picture element of an image.

Saturation: The purity of a colour. Maximum saturation is the absence of white, saturation is simply a grey "value". A component of chrominance.

Scaling: Stretching or compacting an image to fit a specified area by changing the number of pixels originally in the image.

Scan Back: A linear (or tri-linear) array CCD placed at the focal plane of a camera to scan the image projected by a lens and record the image in terms of digital data rather than in an analogue form as on film.

Scanner: A device that illuminates and scans a graphic with an optical sensor by measuring the reflected light intensity. The most commonly used are flatbed scanners, where a one-dimensional linear array is physically moved past an object that lies flat and motionless on a glass panel. See also CIS.

Scratch Disk: A hard disk used to temporarily store data. Some programs use a temporary storage area on your hard drive when you are working on your files. If you have two hard drives installed on your computer, ideally one would be considered the master drive and utilised as the system drive. This drive would contain your computer's operating system and other installed programs. The second drive would be referred to as the slave or scratch disk. This drive would be utilised for any temporary data, particularly your virtual memory and as a main storage area for your backups. The idea is that the drives can work simultaneously, reducing the read/write time.

Digital Photographic Imaging

SCSI: Small Computer Systems Interface. An industry standard for connecting peripheral devices that require high data bandwidth to a computer. SCSI is being phased out by Fire Wire. The latest SCSI standard is Ultra-3, with a maximum rate of 80 to 160 Mbps

Seek Time: See Access Time.

Sensor: A device that measures conditions such as motion, heat or light and converts the condition into digital information. An optical sensor detects the intensity or brightness of light.

Serial Port: A multi-purpose port for connecting mice, modems and other devices to the computer. The basic principle of the serial port is to have one line to send data, another to receive data, and several others to regulate the flow of that data.

Sharpening: The accentuation of detail by increasing the contrast between light and dark areas of a graphic.

Shutter Speed Priority: The camera automatically sets the appropriate f-stop while the shutter speed stays at a pre-determined setting.

Shutter Speed: The amount of time the shutter remains open when you activate the shutter release, typically expressed in fractions of a second. The shutter speed controls how long the digital sensor or film is exposed to light. The faster the shutter speed, the less concern there is for blurring due to camera or subject movement. See also Exposure.

Shutter/Flash Sync: Focal Plane (FP) shutters must sync with the flash, otherwise partial frame exposure occurs. Lens shutter cameras expose the entire frame at all shutter speeds. See also Flash Markings.

Digital Photographic Imaging

Shutter: A camera component that opens and closes to allow light to reach the image sensor. Film cameras use mechanical shutters, while digital cameras use either electronic, mechanical, or a combination of both shuttering techniques.

Signal to Noise Ratio: The relationship between the required electrical signal and the unwanted signals caused by interference (measured in decibels, dB). The amount of electronic noise that a scanner's components generate is evident in the final scan as static (like you might see on a poor TV station), especially in dark areas. The signal-to-noise ratio is also known as dynamic range.

Single Lens Reflex (SLR): A camera in which you view the subject through the same lens that captures the picture. The SLR represents the higher-end of the 35mm and digital camera range. Mid-range point-n-shoot cameras, or low-end single use cameras lack the higher quality of the images typically acquired by an SLR.

Size: In relation to image geometry, the horizontal and vertical dimensions of an image.

SmartMedia Card: A small and very thin memory card used in some consumer-class digital cameras to store images. Adapters are available that allow you to convert a SmartMedia card so it can be read by a floppy disk drive, or adapted to a PC Card (PCMCIA) for use in a PC card slot on a notebook computer.

Smooth Gradients: Smooth gradients refer to changes in scene content (colour, hue and saturation, intensity) that are imperceptible, or at least acceptable, to the eye. When an image is compressed using a lossy compression algorithm such as JPEG, it is difficult to compress those parts of an image that exhibit gradual changes in colour. If the image is compressed too heavily, it can show banding.

© 1999 Phil Taylor

Digital Photographic Imaging

Soft Proofing: The image is viewed on a monitor to emulate as closely as possible the final output. See Proof.

Spatial Resolution: The measure of the maximum number of pixels in an image in terms of pixels per unit measure or in terms of pixel dimensions. Spatial resolution of a digital image is usually denoted by ppi, whereas the spatial resolution of output devices is usually given as dpi. Although the two are often interchanged we prefer to look at dpi as covering all devices. An image scanned at 100-ppi has lower spatial resolution than an image scanned at 300-ppi.

Specular Highlights: A reflection of bright light, where the light source is small but very intense. An example would be sunlight on a chrome car bumper or catchlights in a person's eye.

Spherical Aberration: Where a single element lens does not focus light rays coming through its edges at the same plane as rays through its centre. The effect would be of blurry or out-of-focus areas in an image.

Square Pixels: The shape of the individual pixels generated by some digital cameras, as opposed to rectangular pixels. Computer monitor screens display square pixels and therefore better accommodate images created with square pixels.

Stepper Motor: A motor that is commonly used in scanners, which moves the sensor in small increments. The smaller the steps are, the greater the resolution will be along that particular direction (Y-direction) of travel.

Stepping: A term that is used in prepress. See Banding.

Stereogram: This type of image is used to recreate the illusion of depth and a three-dimensional effect can be

simulated by a stereoscope. This is accomplished by a pair of pictures that are taken from a similar position, only there is in fact a 2-3 inch separation between the two spots where the pictures are taken. Human eyes are about 2-3 inches apart, and each eye sees an image slightly differently. This separation is the key to the recreation. See also Anaglyphs.

Still: A still is a static, non-moving picture; a single frame.

Stylus: A pen-like device that is used to draw upon a tablet, which translates into the cursor movement on your screen. The tip may also be pressure-sensitive and perhaps an erasing tip will be on the other end, which activates an erasing mode through your graphics software.

Subjective Evaluation: Image quality evaluated through an emotionally or aesthetically driven human assessment. See also Objective Evaluation.

Sublimation: The process by which a solid becomes a gas without first passing through a liquid phase. See also Dye Sublimation.

Subsampling: When a device is configured to scan a target at a sampling rate less than its optimum settings. Visibly noticeable as pixellation in an image. See also Oversampling.

Substrate: The material on which the data that represents an image is printed or stored. Examples include paper, plastic, magnetic disk or optical disc material. See also Medium.

Subtractive Colour: See CMYK.

SVGA: Super VGA. This is a common setting for a computer monitor, but not widely used for digital still cameras. At 800 x 600 pixels, it represents an aspect ratio

of 4to3 (1.3) which conforms to the frame aspect ratio of NTSC video.

Sweet Spot: A term often used to describe the "best" part of an optical system. This may refer to the area that offers the highest resolution, most clarity, or the least amount of optical distortion. For camera lenses, the sweet spot is typically the central region where the optical resolving power is the best, with the lens typically at f8.

SXGA: Super XGA. 1280 x 960 represents an aspect ratio of 4to3 (1.3) which conforms to the frame aspect ratio of NTSC video.

T

Tablet: A tablet utilises a pen-like device (Stylus) that is used to draw upon it. The tablet in turn detects the movement of the pen and translates this into the cursor movement on your screen.

Texturing: This is a method of wrapping a surface with a "skin" in a rendering program. Also, providing the image with a three-dimensional appearance.

TGA: Targa files used for high resolution graphics for Targa-brand graphics boards. It is a bitmap file format for images up to 32 bit RGB.

The Matrix: It's everywhere, it is all around us, even now in this very room.

Thermal Dye Transfer: A printer technology that uses heat to transfer semi-transparent dye onto a unique paper. See also Sublimation.

Digital Photographic Imaging

Thermal Wax Transfer Printer: A medium-resolution colour printer. This technology uses wax-based ink to transfer colour to paper or transparency.

Thumbnail: A small, low resolution version of a larger image, used for sorting and previewing images.

TIFF: Tagged-Image File Format is the standard for high-resolution bitmapped graphics on both PC and Mac. Compression method is LZW providing ratios of about 1.5-1 to 2-1. Brought to you by Aldus & Microsoft.

Tint: See Hue.

Tonal Resolution: See Bit Depth.

Tonal Variations: Changes in tone may be perceived by the degree of lightness or darkness in an image; also referred to as value. Cold tones (bluish) and warm tones (reddish) refer to the colour cast of the image in both black-and-white and colour photographs.

Tonality: The brightness, luminance, or greyscale components of an image. The quantity of light reflected, radiated, or transmitted by any picture element in an image.

Translucent: You are able to see brightness through a material without detail.

Transparent: You are able to see through a material with detail.

Tri-linear Array: This is simply the use of three linear arrays, with each sensor filtered red, green and blue respectively. See also Linear Array.

True Colour: Colour that has a depth of 24-bits and 16.7 million colours. The term True Colour is used commonly

Digital Photographic Imaging

with Macintosh systems (and less commonly on PC systems) to describe display and image properties.

TWAIN: Technology Without An Interesting Name. A cross-platform interface that allows imaging application software to acquire images from scanners and digital cameras. See Drivers.

U

UGA: UGA has a display area of 1600 x 1200 pixels. 1600 x 1200 pixels represents an aspect ratio of 4-3 (1.3) which conforms to the frame aspect ratio of NTSC video.

Undo: A function in many software programs that allows you to revoke the last step that you completed. Certain programs may actually permit repeated undo's.

Uniformity: Rendering of the average grey level is the same at various locations across a test target. Most scanners perform an internal calibration to maintain uniformity. Poor lamp quality or an aged lamp, mechanical misalignment, and even dirt on the scanner's glass surface can cause non-uniform areas to appear on output.

USB: Universal Serial Bus. USB is a high-speed serial connection between a device (peripheral) and your computer. The advantages are – elimination of port conflicts, high-speed data transfer (up to 12Mbps), hot-swap capability, reliable multiple connections (can support up to 127 devices) and transfers, universal cabling, and connectivity between both PC and MAC platforms.

Digital Photographic Imaging

V

Value: The tonal brightness or lightness of a colour.

Vector Graphic: An image composed of mathematically constructed geometric objects such as polygons or lines and points. Unlike a pixel-based bitmap, these images are not limited by resolution and can be scaled up with no loss. Otherwise known as object-oriented.

Vector: A line whose direction and length are mathematically assigned. In relation to a class of CCD, this refers to the elements being positioned in a row. See also Linear Array.

VGA: Video Graphics Adapter. Digital cameras with a resolution of 640 x 480 are called VGA-class cameras. 640 x 480 represents an aspect ratio of 4-3 (1.3), which conforms to the frame aspect ratio of NTSC video.

Video In/Out: A feature of many consumer-class digital cameras that allows you to connect the camera to the Video In connector on your TV to display your digital pictures on TV. Just to clarify what some video standards for other countries are called – France-Secam, British-PAL and North American-NTSC

Video Resolution: CRT resolutions are usually given as number of pixels per scan line, and the number of scan lines. e.g. 640 X 480 (NTSC), 768 X 512 (PAL).

Viewer: These types of programs allow you to look at most file formats at a single glance. Features may include organizational capabilities.

Viewfinder: For consumer digital cameras there are two types – optical and electronic. Electronic viewfinders may

Digital Photographic Imaging

come in the form of an image <u>LCD</u> panel that displays the image to be captured for previewing purposes. An optical viewfinder is like that provided on a 35 mm camera.

Virtual Memory: This is a swap file on your hard drive that is acknowledged as <u>RAM</u> by the operating system. An option for any computer with a hard drive, but is slower than conventional RAM. When the operating system runs out of RAM, it utilises the virtual memory to free up some RAM. This is done by swapping portions of data to your hard drive until they are required.

Volatile Memory: Refers to a type of storage medium that is susceptible to data loss. This loss may be encountered when the power supply is shut off, as with RAM. Disks and tapes are considered volatile storage devices, as the data is stored magnetically and therefore subject to accidental erasure.

W

Wallpaper: Wallpaper is a graphic image designed for decorating your computer's desktop. On a Web page, it is called a background. The file format for Windows has traditionally been a <u>BMP</u>.

Water Fastness: A printed image's ability to resist the application of water upon the substrate, as with <u>resin coated paper</u>.

Web-safe colour palette: Consists of 216 colours that will not shift or dither on computers set to display 256 colours. These 216 colours will display consistently across all platforms and Web browsers. The reason it is 216 colours instead of 256 is because Macintosh and Windows each have 40 colours reserved that are unique to the operating system.

Digital Photographic Imaging

White Balance: The ability of a camera to maintain white as white, by correcting colour and tint when shooting under varying lighting conditions. This would include daylight, shade, tungsten, and fluorescent lighting.

White Point: The numerical value 255 of a pixel.

Wide-Angle Lens 📷: A lens with a short focal length (such as 24mm or 28mm). These lenses produce a smaller image of a subject at a given distance than a normal lens, but at the same time a wider field of view.

Wireframe: The skeletal structure that is the core of three-dimensional object design.

WORM: Write-Once-Read-Many. A technology used with optical disks. WORM is a removable data storage media that cannot be altered once written. Nonetheless, it may be read as many times as required.

WYSIWYG: "What You See Is What You Get". A desktop publishing term meaning what's on your screen is generally what will be printed or output in some manner.

X, Y & Z

X-direction: This is the direction the elements in the CCD array of a scanner are aligned.

XGA: XGA refers to a camera that captures images at a resolution of 1024 x 768 pixels, with 256 colours. 1024 x 768 represents an aspect ratio of 4-3 (1.3), which conforms to the frame aspect ratio of NTSC video.

YCC: A colour model that is the basis of Kodak's PhotoCD system. RGB data is translated into the three new components, "Y" being the luminance or brightness and the "CC" being chrominance and hue.

Y-direction: This is the direction in which the step motor of the scanner moves the CCD array.

www.ingramcontent.com/pod-product-compliance
Lightning Source LLC
Chambersburg PA
CBHW021015180526
45163CB00005B/1958